PROPERTY OF
CANTON LOCAL SCHOOLS

Bok!

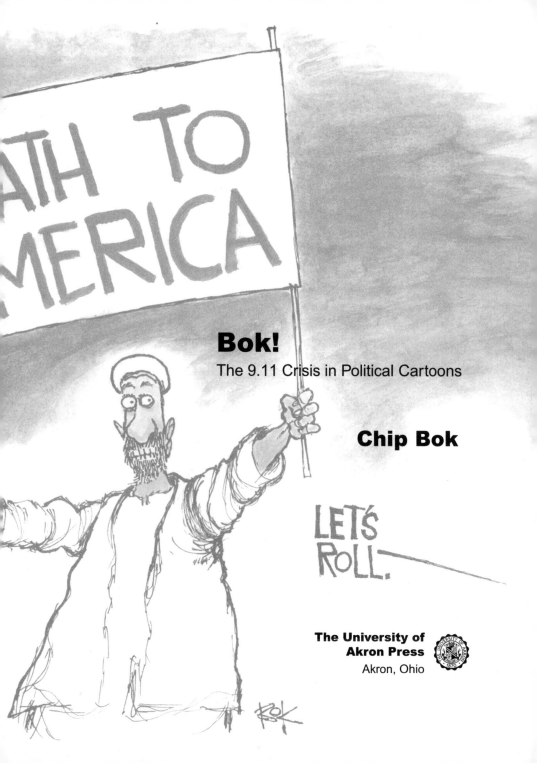

Bok!

The 9.11 Crisis in Political Cartoons

Chip Bok

The University of Akron Press
Akron, Ohio

Copyright © 2002 by Arthur Bok

All rights reserved

All inquiries and permissions requests should be addressed to the
publisher, The University of Akron Press, Akron, OH 44325–1703

Printed in Korea

First edition 2002

05 04 03 02 5 4 3 2 1

Library of Congress Cataloging-in-Publication Data

Bok, Chip, 1952–

 Bok! : the 9.11 crisis in political cartoons / Chip Bok.—
1st ed.

 p. cm. — (Series on international, political, and economic
history)

 ISBN 1-884836-89-5 (hardcover : alk. paper) —

 ISBN 1-884836-90-9 (paperback : alk. paper)

 1. September 11 Terrorist Attacks, 2001 — Caricatures and
cartoons. 2. War on Terrorism, 2001 — Caricatures and cartoons.
3. Terrorism — Caricatures and cartoons. 4. Anti-Americanism —
Caricatures and cartoons. I. Title: 9.11 crisis in political cartoons.
II. Title: Nine.eleven crisis in political cartoons. III. Title.
IV. Series.

 HV6432 .B65 2002

 973.931'022'2—dc21

<div align="right">2002074345</div>

The paper used in this publication meets the minimum require-
ments of American National Standard for Information Sciences—
Permanence of Paper for Printed Library Materials, ANSI Z39.48-
1984. ∞

Introduction

H as the world changed since September 11? It has for at least one group of subversive operatives. I'm speaking, of course, of the small, yet poorly organized, cells of individuals who take advantage of the freedoms this nation provides to carry out their roles as political cartoonists. I'm one of them and this is my story. I've operated inside these borders for many years, confounding immigration officials by the simple, yet elegant, strategy of being born here.

The primary targets of my drawing have always been the leaders of my own government: mayors, councilmembers, legislators, governors, judges, and presidents. That's what cartoonists do and that's what the public expects of us. But what happens when the government is attacked, not with sarcasm and satire, but with commercial aircraft loaded with jet fuel, destroying national landmarks and killing thousands of people? When I target public figures and institutions, my intention is to provoke thought, to amuse, and maybe to play a micro role in changing things for the better. Whatever the ultimate goals of the suicide bombers were, they involved the mass killing of innocent people. My first impulse was to want to make it clear I had nothing in common with those guys. When the president said it was time to choose sides, not many were raising their hands for the "evildoers." We mostly wanted to identify with the New York firemen and policemen, and with the "let's roll" guys who took on the hijackers of United Airlines Flight 93 before it crashed near Somerset, Pennsylvania.

The changes were abrupt. Support for President Bush skyrocketed among people who, on September 10, did not support even the idea that Bush was presi-

dent. It was hard to draw cartoons in the immediate aftermath of the attack. The magnitude of the loss, along with the courage of the firefighters and everyday people, was too overwhelming. When it all gets to be too much, America's cartoonists draw weeping Statues of Liberty. I wanted to avoid that image, but I did not do much better. I compared the event to the sneak attack on Pearl Harbor and called it Infamy II.

I was no different from the average American who felt a loss of security and wondered what was coming next. I also shared enough blissful ignorance with my fellow Americans to be surprised and irritated by the cheering crowds of Palestinians. I had been aware that a lot of people in the rest of the world resent American power. But when they say they hate America I assumed they meant it the way Americans outside New York mean it when they say they hate the Yankees. Not many Yankees haters would kill themselves just to hurt George Steinbrenner. In fact, the effects of the September 11 attacks were so great that many of those same people loved the Yankees that October.

Before September 11 I did not find the people who hate America nearly as interesting as the U.S. Supreme Court's putting Bush over the top in the 2000 presidential election. I do now. That's the main effect the September 11 attacks had on political cartoons. In that sense maybe the terrorists did win: they got me to pay attention to them.

Beyond the slipping and sliding, looking for cartoon traction in the first week or so after the attack, it seems to me political cartooning has not changed all that much. It just has a new purpose. There are not many cartoons about the legitimacy of the Bush presidency anymore. There were no more Gary Condit cartoons or Monica Lewinsky cartoons either. Instead we have life and death issues like war,

weapons of mass destruction, America's role as the sole superpower, and why *do* all those people hate us?

People have a lot of ways to label cartoonists: liberal, politically correct, conservative, libertarian, witty, or stupid. Cartoonists themselves for some reason have narrowed the categories to two: hard-hitting or funny.

The hard-hitting camp wants to be taken seriously because we draw about news, and news is serious stuff. These cartoonists strongly believe we are not put on this earth to illustrate the news or make a gag. We are here to express the firm and fiercely independent opinion that the news is serious—and preferably to do it in a way that will offend the readers . . . and result in canceled subscriptions.

The funny camp, on the other hand, sees current events merely as a platform for launching gags that make readers laugh but not think. This may cause circulation to increase, but far more important, it will cause the cartoonist's syndication sales to increase. With an enormous following, the funny cartoonist dreams of reaching the status of a late night comedian, which is what he always wanted in the first place but was too shy to seek.

Each of these two camps exists firmly in the mind of the other. For my own part, I'm solidly in the hard-hitting camp, except that I think it's all so damned funny. Until September 11, that is.

Now we do have serious news to draw about and a steady diet of it.

What do we owe to the victims of the attack? What do we owe to the families of the soldiers who die in combat because of the attack? Should there be a limit to the war on terrorism? What should be done with the terrorists? And what about our allies? They say we are arrogant and that we do what we want in the world without consideration for others. This is also what the terrorists say. Why don't our

allies attack us? Should Israel be our ally? Did our friendship with Israel cause us to be attacked? What is it with radical Islam and what is it with the U.S. shadow government? How come all our other friends in the Mideast are undemocratic and why don't they do something for the Palestinians? Will the terrorists "nuke" us if they get the chance? Couldn't this all be settled through conflict resolution facilitated by your company's human resource director?

These important questions are taken up by politicians every day, making prime subject matter for political cartoonists. We've moved way beyond the stunned first days of weeping Statues of Liberty and comparisons to Pearl Harbor. The best way to honor the common people and heroes lost that day, and since, is with the lively debate, complete with satire and sarcasm, that gives life to the democracy they died for.

This book contains a collection of my cartoons from that day forward. I hope you find them seriously funny.

C. B. 3•27•02

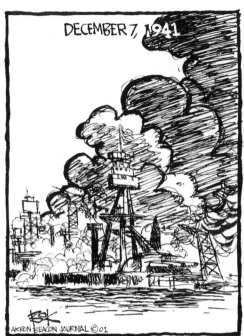

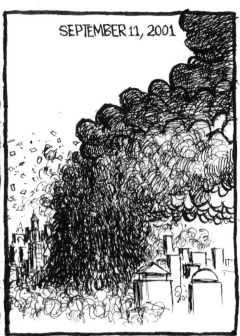

INFAMY II

On December 7, 1941, Japan attacked the United States, killing 2,403 people. On September 11, 2001, Islamic extremists struck the United States, hijacking four commercial passenger jets, targeting New York City and Washington, D.C., killing approximately 3,000 people, destroying the World Trade Center, and seriously damaging the Pentagon. Thanks to the courage of the passengers of United Airlines Flight 93 over Pennsylvania, the enemy did not achieve total victory. President Franklin D. Roosevelt described it best the first time.

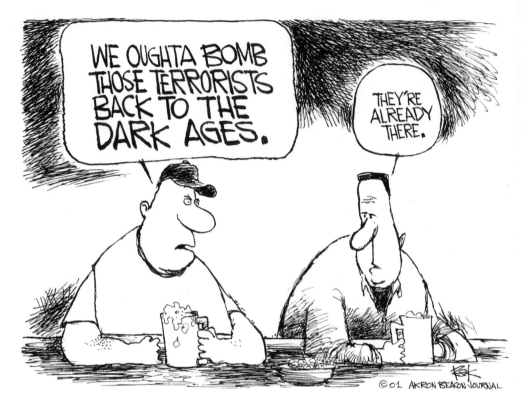

The enemy seemed to be some sort of primitive medieval

force, which made it all the more stunning that they could use

our technology against us so effectively.

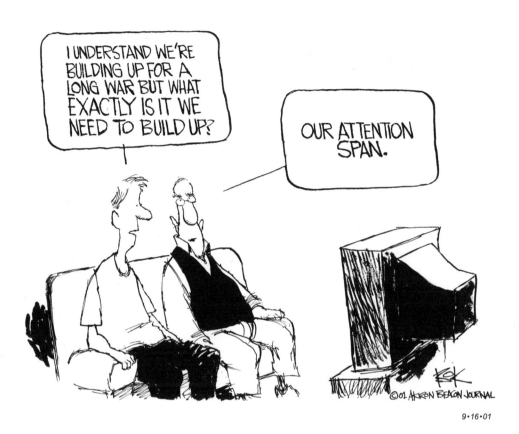

The president began preparing the country for a long war. The population was wildly enthusiastic, but past experience has shown us to have an extremely short memory when it comes to current events. I would name some examples but I've already forgotten them.

The response to the terrorists was still in its formative stage in mid-September. Osama bin Laden was named the prime suspect, but it wasn't clear if the U.S. military would track him down or if an international task force would be formed to do the job. Editorial cartooning is a negative art. It lends itself more to jabbing the bad guys than to glorifying the good guys. Usually this is a good thing since politicians spend so much of our money glorifying themselves. But these are unusual times. I was looking for a way to say something nice about the New York firefighters.

In this case I did just what your mother always told you not to do: I mocked bin Laden to make the firefighters look good. Not that there was anything I could do to improve the FDNY's well-deserved heroic image, but they liked the cartoon. I sold the original in a fundraising campaign sponsored by the *Beacon Journal* to buy a new fire truck for New York City and gave a signed copy to John Murphy, retired, of Ladder 17 in the South Bronx.

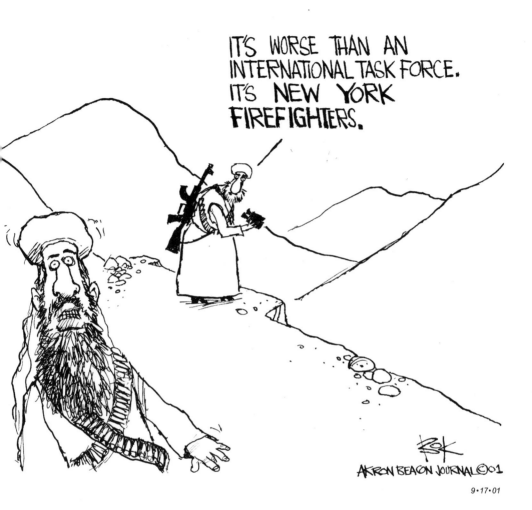

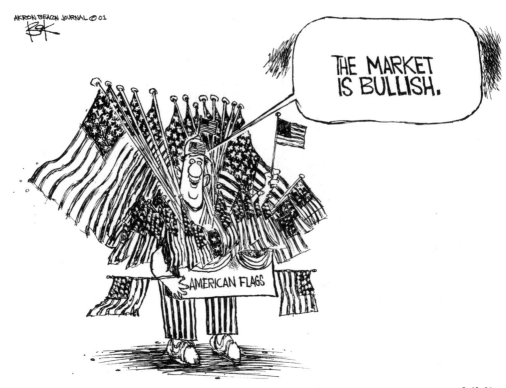

The economy was already in recession when the
New York Stock Exchange opened on September 17
for the first time since being closed September 11.
The Dow plunged 684 points that day, but patriotism
was off the charts. Stores had trouble keeping flags
in stock as people raised them everywhere.

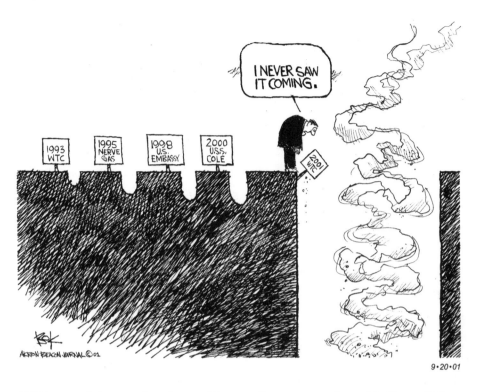

Within a week the questions began. Why was the government caught off guard? On February 26, 1993, Islamic terrorists blew a five-story hole in the basement parking garage of the World Trade Center, killing six people and injuring over a thousand. Twelve people were killed and 5,000 injured when the Aum Shinrikyo cult released Sarin gas in the Tokyo subway on March 20,1995. In Nairobi, Kenya, 213 people were killed in a suicide bombing of the U.S. embassy on August 7, 1998, and 11 were killed in a simultaneous explosion at the U.S. embassy at Dar es Salaam, Tanzania. On October 12, 2000, the *USS Cole* was attacked by suicide bombers in small boats. The destroyer was severely damaged and seventeen sailors were killed. The al Qaeda network is suspected in the *Cole* and both embassy attacks.

Two days after the attack, on *The 700 Club* with the Rev. Pat Robertson, Jerry Falwell said, "What we saw on Tuesday, as terrible as it is, could be minuscule if in fact God continues to lift the curtain and allow the enemies of America to give us probably what we deserve." Didn't sound much different than bin Laden's claim in his video televised December 13 that it was only through God's will that the damage to the towers exceeded even his expectations. (Videotape translated by George Michael of the Diplomatic Language Services and Dr. Kassem M. Wahla, Arabic Language Co-ordinator, School of Advanced International Studies, Johns Hopkins University.)

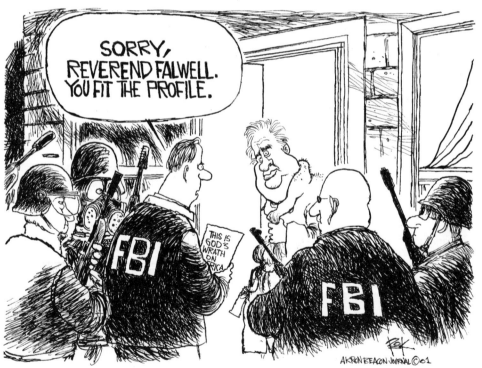

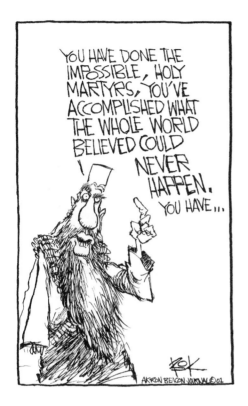

9·23·01

Senators Tom Daschle and Trent Lott pledged to put party differences aside and work together. The Senate voted 100–0 on a bill to make airport security workers federal employees.

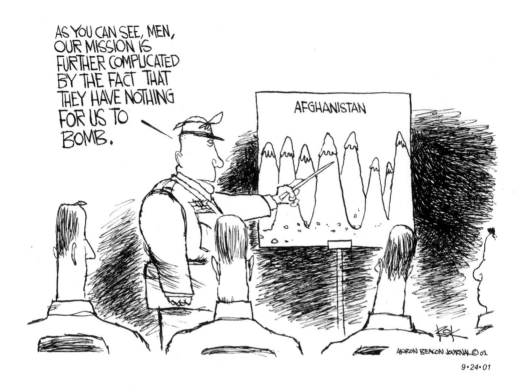

As it turned out, the military found plenty to bomb. The Taliban and al Qaeda were routed and scattered. As always in war, many civilians suffered casualties too.

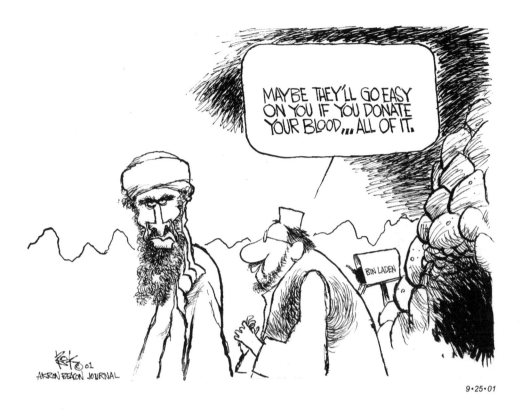

Donating blood for the World Trade Center victims was a popular way to show support. Palestinian leader Yasser Arafat wasted little time getting a photo opportunity while giving blood. I vainly hoped that perhaps Osama would try to one-up him.

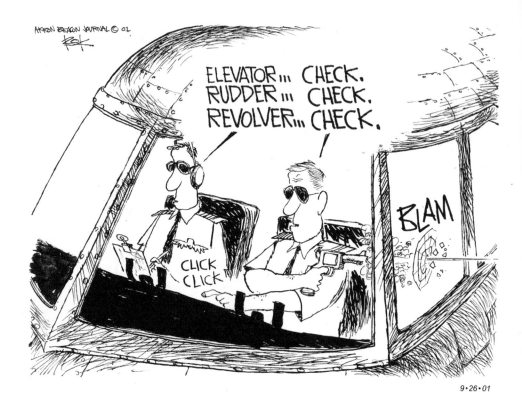

Duane Woerth, president of the Air Line Pilots Association, testified before Congress on September 24, 2001, that he would ask Congress to permit pilots to carry guns on flights. While there are, apparently, effective bullets that can stop short of penetrating an aircraft's skin, many pilots found the idea to be risky.

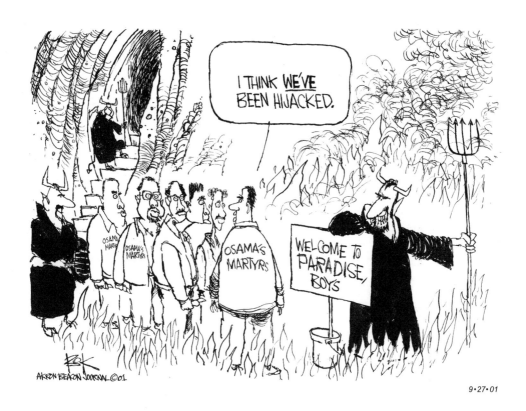

I could not comprehend what kind of enemy could carry out a highly scripted assault that requires his own death. A letter left behind by Nawaf Alhazmi, one of the suspected hijackers, states his belief that he would be in paradise via martyrdom in Jihad. I'm no religious expert, but maybe he missed some fine print forbidding suicide.

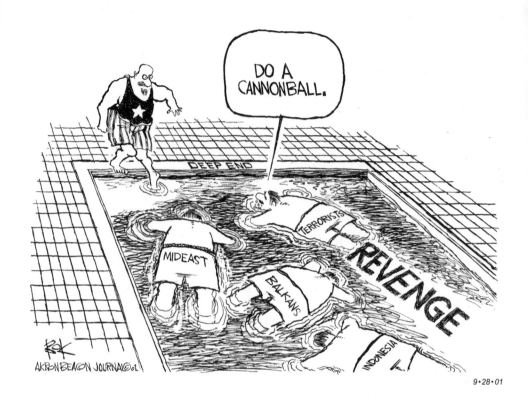

The suicide bombers lived in a world of hate built on a cycle of avenged atrocities spanning generations and centuries. The United States and its Western partners live outside that world. I think the purpose of the attacks on September 11 was to create an atrocity big enough to trigger an American response in that world of vengeance. They invited us to make a big splash in their pool.

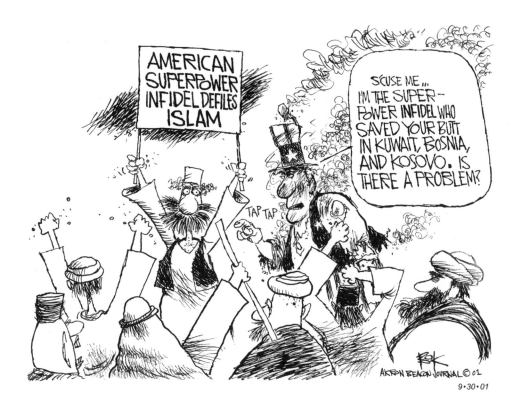

Why do they hate us? Still in a state of shock from the collapse of the twin towers, Americans had their feelings hurt by the gleeful demonstrations on the Arab streets. I doubt it ever occurred to the average American that U.S. troops on Saudi soil were a religious insult. When we thought about it at all, which was hardly ever, we assumed they were there to protect the Saudi regime, and Saudi oil (so it could become our oil), from Saddam Hussein. We even used a lot of that oil at 15,000 feet to save Muslims from Yugoslav president Slobodan Milosevic.

Prior to the September 11 attacks, a major environmental concern was President Bush's proposal to allow a few extra parts per million of arsenic in the drinking water. There was a time when people were concerned about chemicals on food, spread in many cases by crop-dusters. That concern was mostly overcome by a greater concern for cheap food. The anthrax scare brought a more urgent sort of environmental consciousness back into style, sending some people scurrying for gas masks and the antibiotic antidote, Cipro.

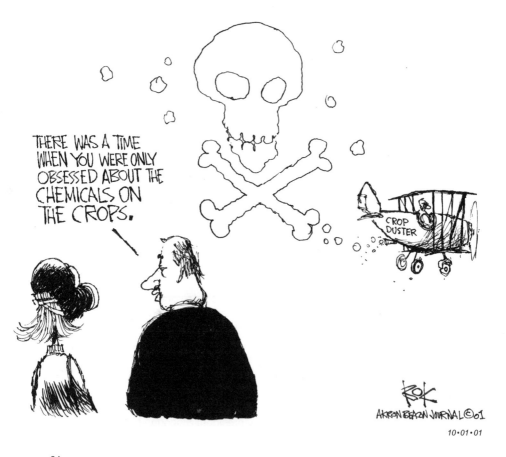

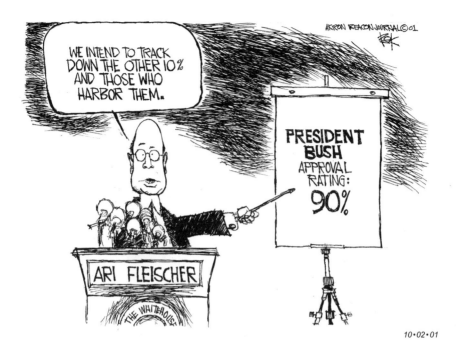

WE INTEND TO TRACK DOWN THE OTHER 10% AND THOSE WHO HARBOR THEM.

PRESIDENT BUSH APPROVAL RATING: 90%

ARI FLEISCHER

THE WHITEHOUSE

10·02·01

Bill Mahr, the host of the television show *Politically Incorrect,* made a statement that was (surprise) politically incorrect. He said that the suicide bombers, rather than being cowardly, as the president described them, were actually quite brave. His argument was that they willingly carried out a mission requiring the sacrifice of their own lives. The fact that the mission also included the unwilling sacrifice of approximately 3,000 innocent lives was evil, but not cowardly. In ordinary circumstances, it might be a reasonable thing to say, but it was not the sort of consolation a bereaved nation was seeking. Enter Ari Fleischer, White House press secretary, to raise the stakes by publicly warning that people had better watch what they say. The president already enjoyed the nation's overwhelming support, and this little display of zero tolerance for dissenting opinions deserved a dissenting opinion.

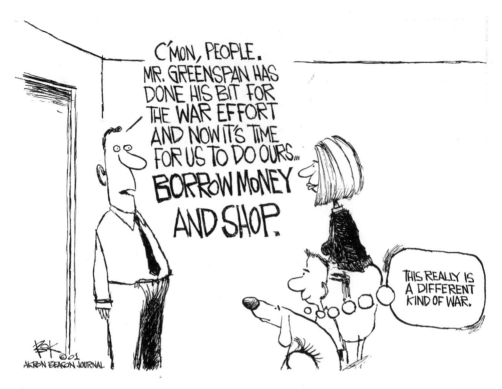

President Bush stressed that this would be a different kind of war. People supported other wars by buying war bonds, rationing raw materials, and not wearing nylon stockings. Federal Reserve Chairman Alan Greenspan said that our duty was to prevent the economy from tanking, and the way to do that was to get out there and buy stuff. We saw our duty and we did it.

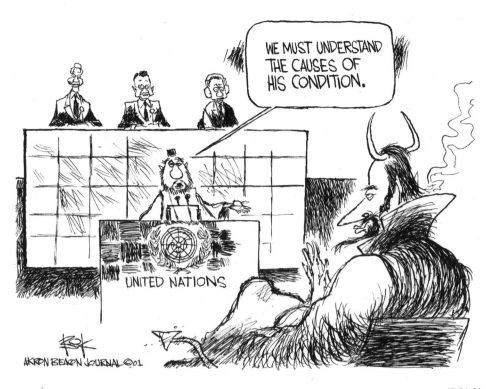

Displaying a sense of timing every bit as keen as that of *Politically Incorrect's* Bill Mahr, Middle Eastern Muslims went before the United Nations and asked for understanding of the root causes of Islamic anger.

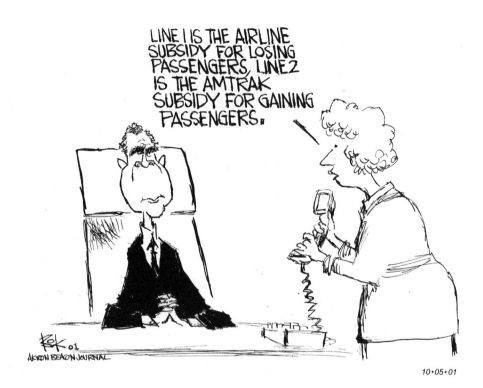

One of the government's first responses was to compensate the airlines for loss of business after the pinpoint accuracy of their passenger aircraft as ballistic missiles was so clearly demonstrated. With people afraid to fly, but still needing to go places, Amtrak's ridership suddenly swelled. Only in the world of Amtrak would an increase in business be seen as a need for more government subsidy.

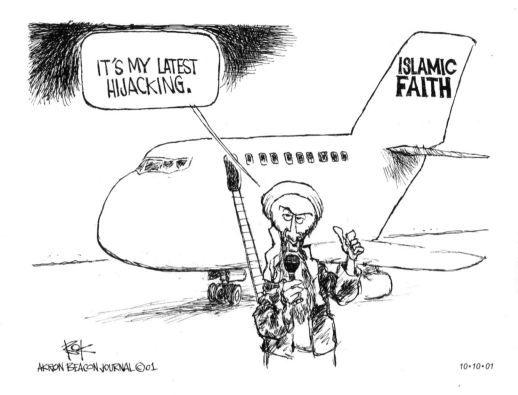

Most Americans, including me, were ignorant about the Islamic faith, and that put us on the defensive. For all we knew, Osama bin Laden was the pope of a religion of death. It did not take a lot of information to multiply our understanding. Some Muslims spoke out on behalf of a religion of compassion, but it seemed as if many others were afraid to speak. It was reasonable to wonder if bin Laden had not hijacked a religion too.

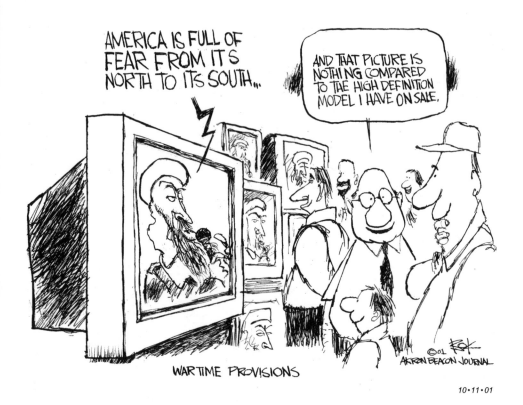

WARTIME PROVISIONS

10·11·01

On the video translated by the Associated Press on October 7, released as the bombing of Afghanistan commenced, bin Laden claimed, "There is America, full of fear from its north to its south, from its west to its east. Thank God for that." If this was true, Americans were not showing it. They seemed concerned and supported the war, but normal life went on. College and pro football games were interrupted for one week before resuming to sellout crowds, and a spectacular World Series went off without a hitch. The population seemed unmoved by anything bin Laden had to say.

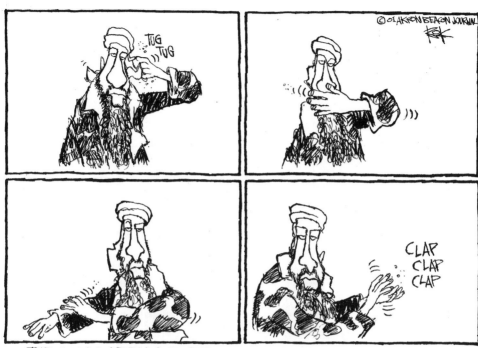

THE BIN LADEN VIDEO... UNEDITED DIRECTOR'S CUT

10·12·01

The television networks agreed not to show unedited videotapes released by Osama bin Laden in case coded messages had been embedded in the videos, for terrorists in "sleeper cells" in the United States awaiting orders for their next attack. Experts say this is possible, but I could not help being amused by the image of a cave man sending signals like a third base coach over the airwaves.

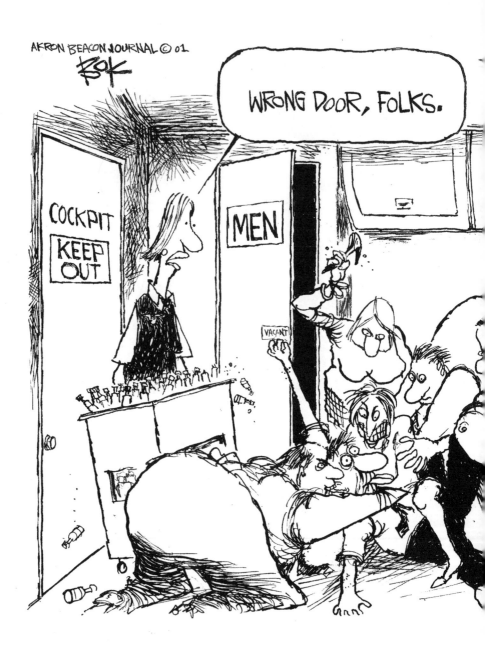

10·14·01

America may not have been in fear from its north to its south, but the flying public was decidedly jumpy. Air travelers also had developed a sense of *heightened awareness* and responsibility for their own safety. This was, no doubt, partly inspired by the passengers of United Airlines Flight 93, who attacked their hijackers, apparently aborting an attack on Washington, D.C. The plane crashed in the Pennsylvania countryside, killing everyone on board. In memory of Todd Beamer's "Let's roll," every movement during air travel was viewed with suspicion. Don't even think of going near the cockpit door.

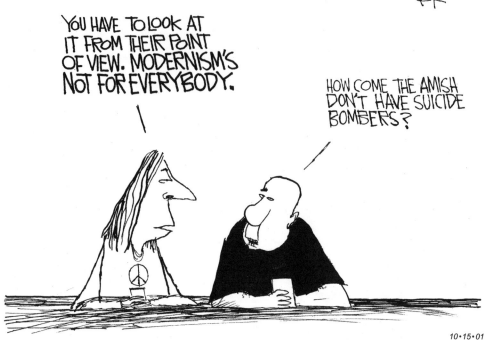

Not accepting Western ways of modernism is understandable. God knows Westerners are crass, material, and shallow. Just flip on the television. But is it really necessary to kill all of us? Some religions quietly retreat from modern life. Maybe it requires modern Western ways to protect their right to do so.

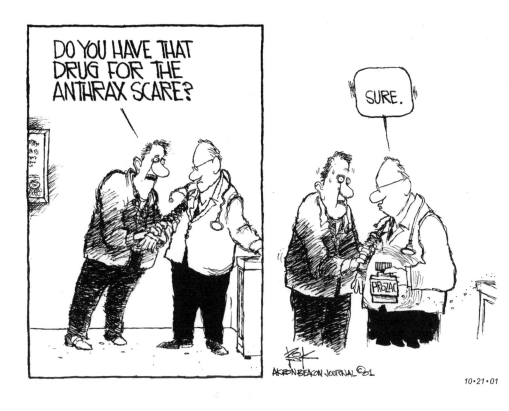

The discovery of anthrax in Washington, D.C., Florida, New Jersey, and New York led to a full-blown outbreak of 24/7 media coverage. Millions succumbed to the hysteria, though it probably was not so hysterical for the people who actually caught the disease. For everyone else, other prescriptions might have been more effective than Cipro.

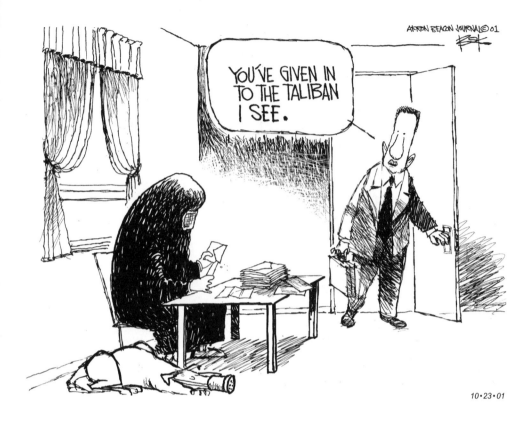

The preferred method of anthrax spore dispersal appeared to be the U.S. mail. I get my fair share of questionable mail in good times, so now I hold my breath longer than usual when I open letters. The bulky bio suits that health officials wore for protection against anthrax made me wonder if that might not explain the head-to-toe burquas worn by Afghan women.

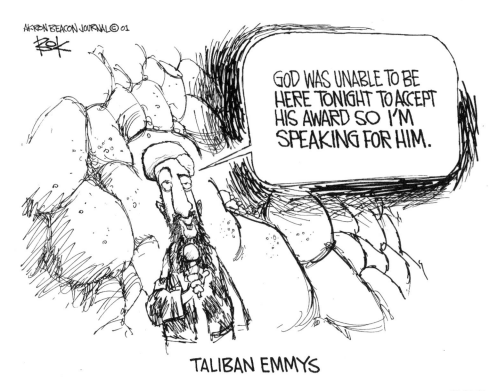

TALIBAN EMMYS

10·24·01

The Emmy Awards were postponed several times. The delays may have been out of respect for the twin towers disaster, or maybe the TV moguls and stars believed they were important enough to be attacked themselves. In any case, Osama bin Laden had demonstrated a flair for drama as divine spokesman on the Arabic version of CNN, al Jazeera. In another time and place he might have fit in well with the Emmy crowd. If the television powers had presumed to issue an award to a higher power, bin Laden would not have hesitated to stand in for the Almighty.

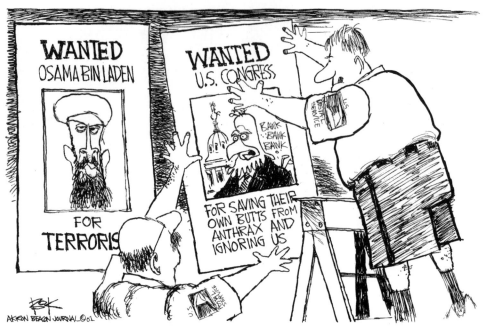

10·25·01

A whiff of anthrax in the halls of Congress was enough to shut down the nation's Capitol. Never mind that the spores arrived by mail, nothing was done to protect postal workers until somebody died. Add anthrax spores to the list of rain, sleet, snow, and dark of night.

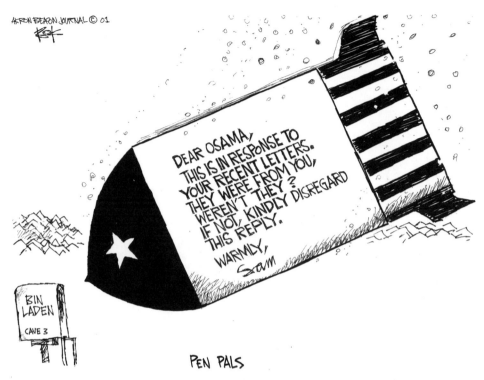

AKRON BEACON JOURNAL © 01

DEAR OSAMA,
THIS IS IN RESPONSE TO
YOUR RECENT LETTERS.
THEY WERE FROM YOU,
WEREN'T THEY?
IF NOT, KINDLY DISREGARD
THIS REPLY.
WARMLY,
Sam

BIN
LADEN
CAVE 3

PEN PALS

10•26•01

Tracking down the anthrax spore mailer, or mailers, proved difficult. There was no shortage of homegrown Unabomber types capable of the deed, but the preferred suspect lived in a cave in Afghanistan. Inasmuch as President Bush had proposed a pen pal campaign between American and Afghan children, I figured he might want to initiate his own cross-cultural mailing.

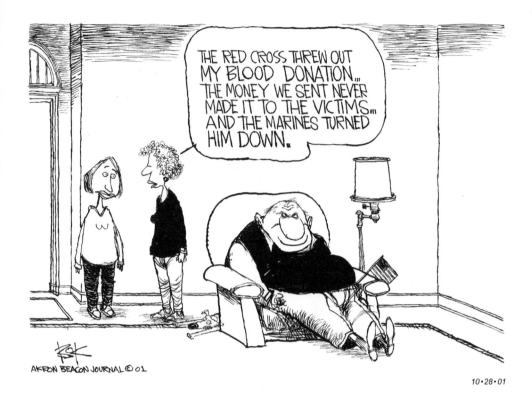

AKRON BEACON JOURNAL © 01

10·28·01

There was little the average American could do to help. More blood was donated than was needed by survivors. Americans opened their wallets, but there were arguments over which survivors were most deserving, and some of the money was simply stolen. As far as a direct military commitment from our nation of couch potatoes: forget it.

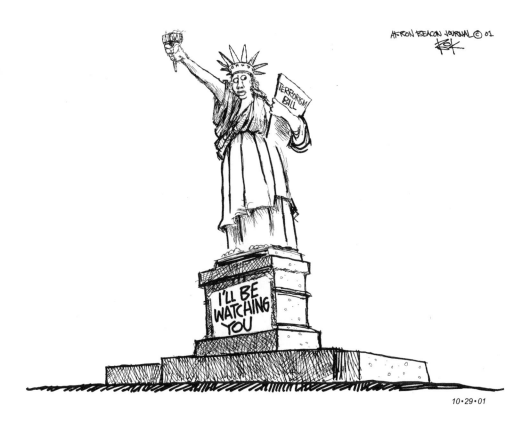

ATKRON BEACON JOURNAL © 01

TERRORISM BILL

I'LL BE WATCHING YOU

10·29·01

Under "heightened security," immigrants, especially males of Middle Eastern descent, came under scrutiny and were "invited" to come in for questioning. The immigration department also cracked down on expired visas. (That didn't stop the INS from issuing student visas to expired hijackers six months later.)

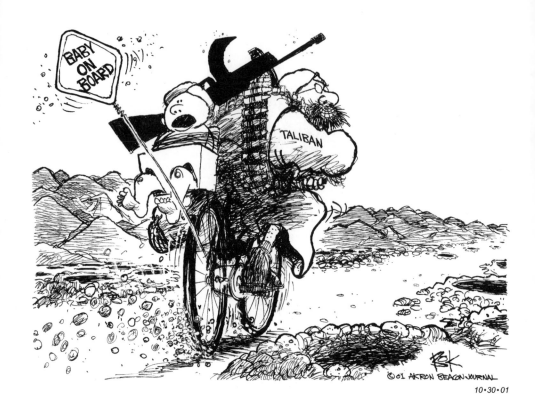

Under the American bombing attack, the Taliban tried to position itself close to civilian nontargets. Taliban leaders hoped Americans would consider them non-targets too, rather than risk civilian casualties. The U.S. military seemed unmoved by the strategy.

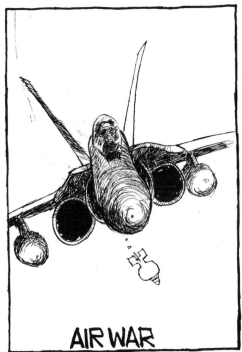

AIR WAR

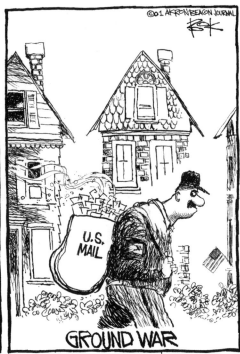

©01 AKRON BEACON JOURNAL

GROUND WAR

10·31·01

American airpower was getting the glory but the foot soldiers taking the casualties, at this point from anthrax, carried the mail.

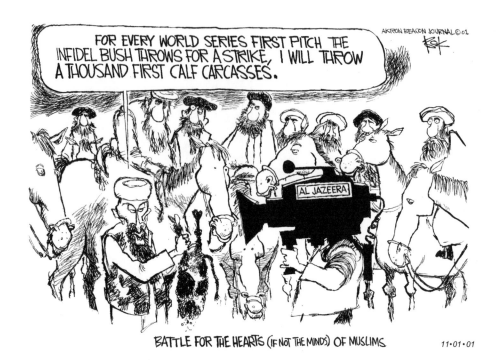

BATTLE FOR THE HEARTS (IF NOT THE MINDS) OF MUSLIMS 11·01·01

President George W. Bush, wearing a flak jacket under a sweat shirt, strode to the pitching rubber in a packed Yankee Stadium, under intense security, to throw out the first pitch in the World Series in New York. Without hesitating, he wound up and threw a perfect strike from 60 feet 6 inches. Most dignitaries, in this situation, make a little halfway toss from just outside the batter's box. I had never seen this done by a president before. Not even by George the Elder, a legitimate ballplayer at Yale in his day. I was impressed.

At that time Osama bin Laden was still trying to score points with the Islamic world on the Arab television network, al Jazeera. Perhaps he would upstage Bush by throwing out the first headless calf, the contested objective in buzkashi, the Afghan national game played on horseback.

Media reports that Middle Eastern men were in the United States, seeking freely available information on nuclear reactors, added to the general feeling of dread as Attorney General John Ashcroft continued issuing nonspecific "high alert" warnings.

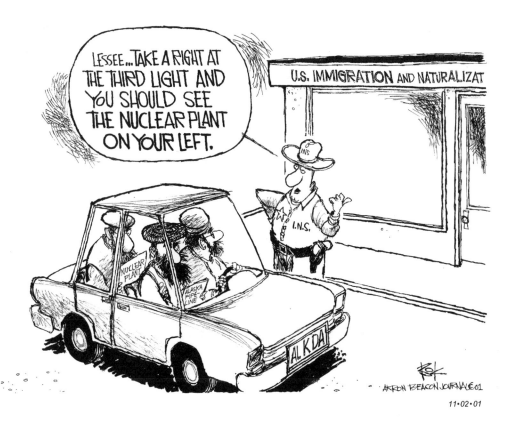

A jumpy nation was hardly calmed by reports of passengers absent-mindedly boarding planes carrying guns and knives while airport security confiscated their fingernail clippers.

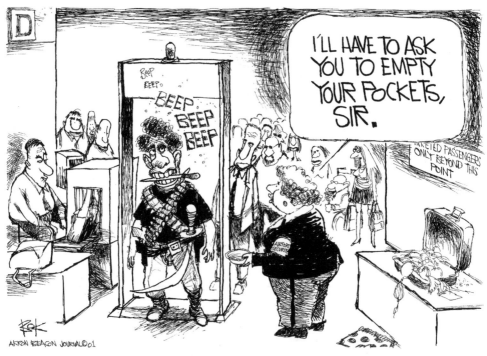

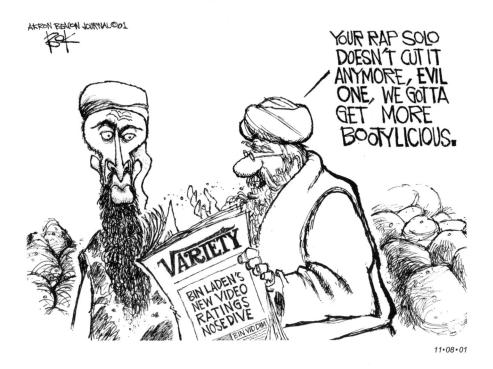

The timing of the first video released by Osama bin Laden was impeccable. As the United States opened the air war, bin Laden was on the air waves, mocking us. The effect was impressive. He appeared for the first time in a cave, or on a set that looked like a cave, with his henchmen and trusty AK-47 nearby. It was rather like The Riddler in a Batman movie, spewing riddles. It made for great television, and news directors played it over and over. Maybe bin Laden suffered from overexposure. Networks held back future video releases for editing and in the end the star's Batman style failed to keep up with the target market's hip-hop tastes.

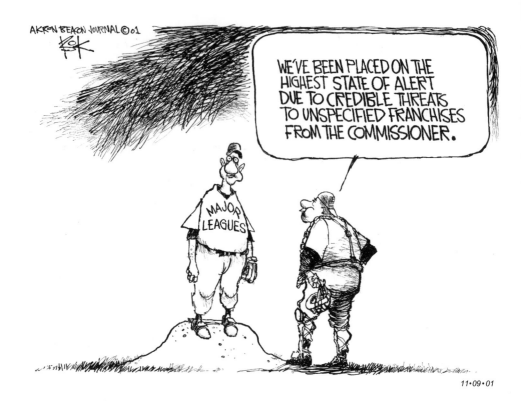

For comic relief from the war drama, baseball commissioner Bud Selig announced the new concept of contraction. Major league baseball would contract by two teams to be named later, probably Minnesota and Montreal. No doubt this unspecified but credible threat put the players on a "heightened state of alert," as Attorney General Ashcroft likes to say.

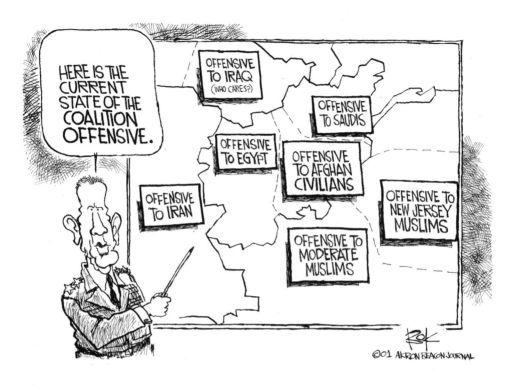

It seemed everyone was offended by the U.S. offensive,

especially our allies, except for the Brits.

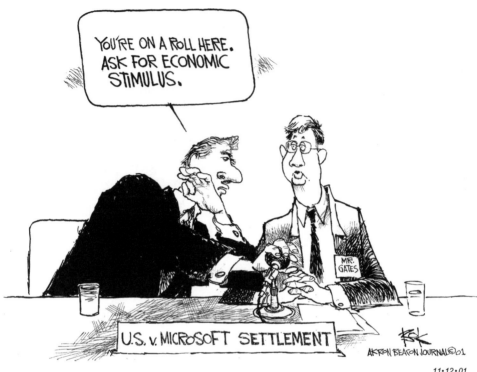

Economic stimulus was not just a matter of making up the airline losses from the September 11 tragedy. Every company in the country seemed determined to get its fair share of your tax dollar. As Microsoft settled the Justice Department's monopoly suit, it seemed it couldn't hurt to ask.

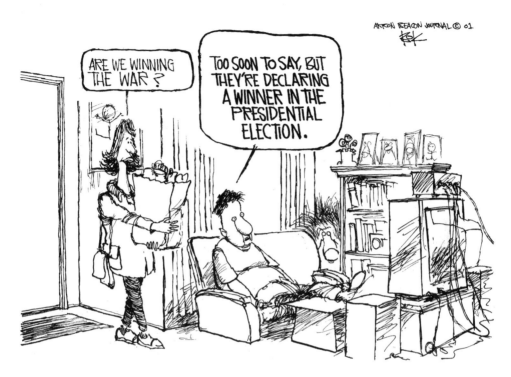

The fact that the United States was well into a war with commander-in-chief Bush enjoying a 90 percent public approval rating must have prompted the news media to announce the news that he was indeed the president. A consortium of newspapers recounted the dimpled chads, and despite a slight Gore margin under one count, they played the story as a Bush victory.

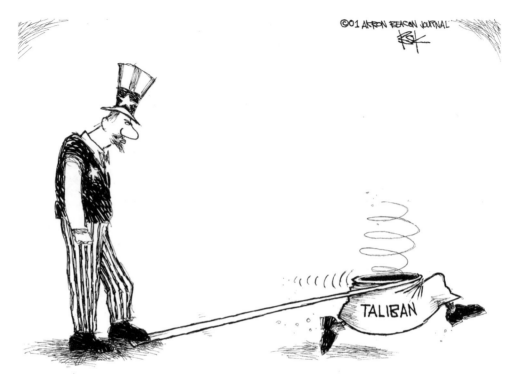

©01 AKRON BEACON JOURNAL

11·15·01

Under U.S. pressure, the Taliban began to unravel.

As the United States became more confident of military success in Afghanistan, it began debating how Taliban and al Qaeda prisoners should be handled. The president called for military tribunals, but others said this would be a denial of the human and legal rights for which we were supposedly fighting. Aside from military justice, we also have civil and criminal justice in this country. I thought of some extreme examples from the different types of law and wondered how they might be applied to Osama bin Laden.

HOW SHOULD THE EVIL ONES BE BROUGHT TO JUSTICE?

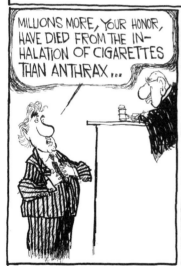

CIVIL COURT...

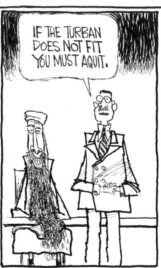

CRIMINAL COURT...

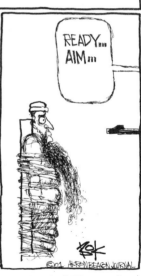

MILITARY TRIBUNAL

11·16·01

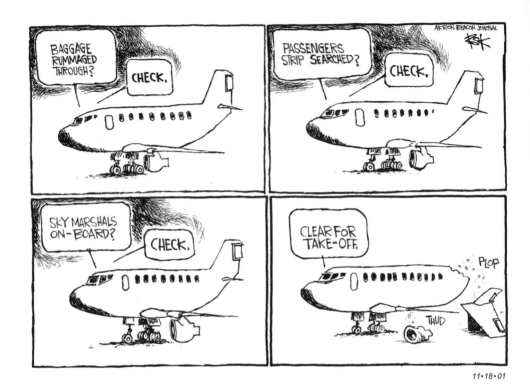

Despite all the precautions in the interest of security, a plane taking off from JFK lost its tail and engines, crashed, and killed everyone on board. The chief suspect was the wind.

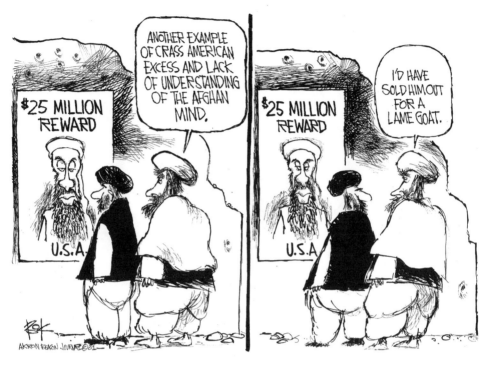

11·21·01

In keeping with the president's "wanted dead or alive" campaign, the U.S. government put a $25 million reward on Osama bin Laden's head. This seemed a little over the top as far as your average Afghan is concerned. Based on his demonstrated willingness to switch sides, trade loyalties, and let the enemy get away, I tried to put the reward in more meaningful terms.

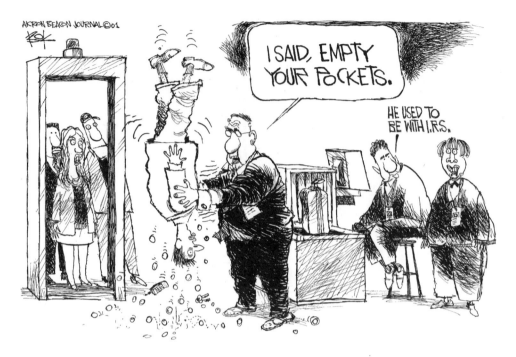

FEDERAL AIRPORT SECURITY REPLACEMENTS

11·22·01

In the frenzy to make American air travelers feel secure, Congress decided to replace inattentive, underpaid, contract security workers with inattentive, overpaid, federal security workers. The flying public is still wary, but Congress seems to feel much better.

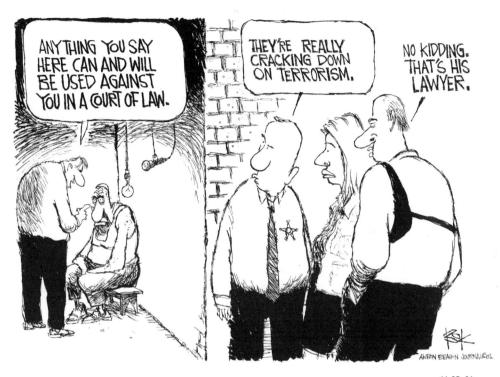

11·25·01

The attorney general was zealous, to say the least, in cracking down on suspected terrorists. Rather than prosecuting terrorists through the usual criminal courts, he proposed using military tribunals. Under the tribunals, initially, the accused still would have been entitled to an attorney, but the government would have been entitled to listen in on all his conversations with the attorney.

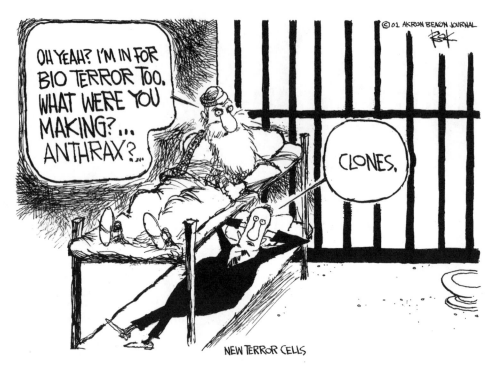

On the bioethics front, the administration moved to outlaw cloning in labs. This was not about cloning human beings but about cloning cells in the hope of creating promising new treatments for disease. It seems one of the prospects for cloning was to increase the supply of stem cells, which would decrease the need for fetal tissue. As the line between bioethics and bioterror got murkier, the climate of fear made for strange bedfellows.

The president seemed to be getting ahead of himself a bit in his obsession with Saddam Hussein. Even if he did try to kill the president's father.

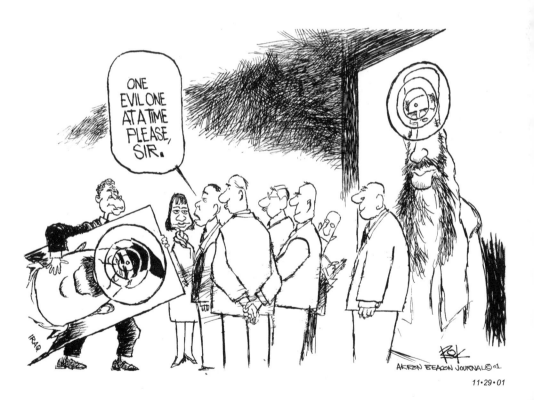

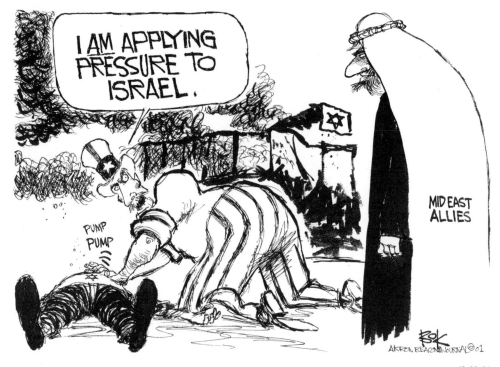

The Palestinians raised the Intifada stakes by escalating suicide bombing tactics themselves. On December 1, a Saturday night bomb killed ten teenagers in a crowded mall in downtown Jerusalem, and fourteen people were blown up on a bus in Haifa Sunday morning. This seemed to send a message to Anthony Zinni, the U.S. envoy who had just arrived to negotiate a peace settlement. Americans, understandably, did not have much patience with suicide bombers—especially since one of the criticisms of the United States was that it had brought the September 11 attacks on itself by not doing enough to bring about peace in the Middle East by applying pressure to its ally, Israel.

The theme that "this is a different kind of war" was reconfirmed, appropriately, on the Larry King show. The television host had the father of the American Taliban, John Walker Lindh, on his show as a guest, after Walker Lindh turned up in the rubble of the Mazar-e-Sharif prison battle. People were stunned to learn of the young American Taliban from Marin County, California. The first American to die in the Afghan war, CIA officer Mike Spann, was killed in the same battle.

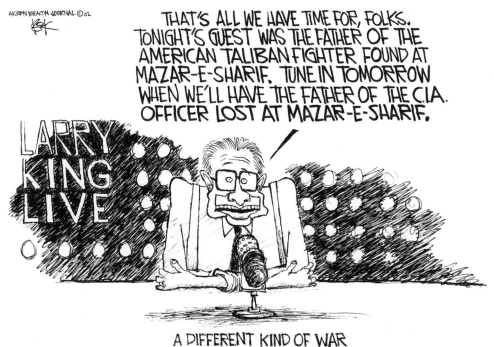

A DIFFERENT KIND OF WAR

12•06•01

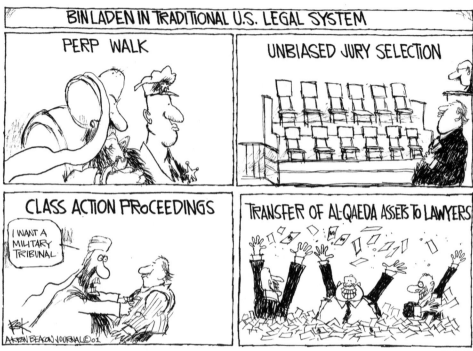

BIN LADEN IN TRADITIONAL U.S. LEGAL SYSTEM

PERP WALK

UNBIASED JURY SELECTION

CLASS ACTION PROCEEDINGS

I WANT A MILITARY TRIBUNAL

AKRON BEACON JOURNAL ©01

TRANSFER OF AL-QAEDA ASSETS TO LAWYERS

12·09·01

As the media discussed the prospect of military tribunals, I wondered what the proceedings would be like if bin Laden were actually processed through the American legal system. He'd be paraded around like a trophy fish by whoever had the honor of prosecuting the case. An unbiased jury would be unlikely in New York. There would be many appeals, no matter what the outcome, followed by a brace of class-action suits and civil actions. In the end, a terrible price would be paid for the tragedy in New York—to the lawyers.

I thought the parents of John Walker Lindh were remarkably sanguine about the fact that their son had joined the Taliban. They seemed pleased that he sought his own identity and was curious and bright. His problem could be recognized immediately by any upper-middle-class American parent as that modern scourge of all bright, overly active boys: attention deficit disorder.

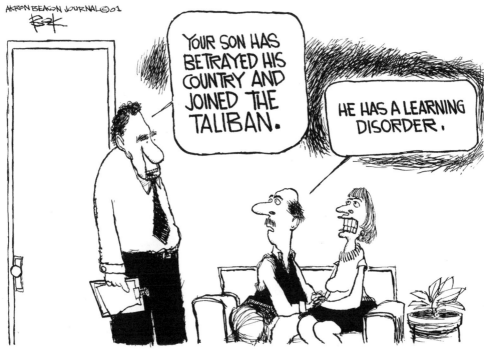

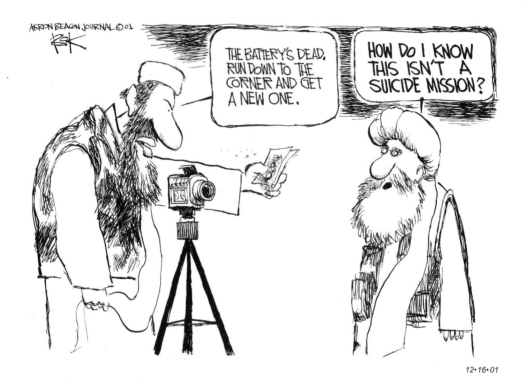

The networks released an edited bin Laden video, stamped November 9. According to a December 11 *USA Today* story by Richard Benedetto, quoting White House officials, "He [bin Laden] expressed amusement that some hijackers of the jets that crashed into the World Trade Center, the Pentagon and a field in Shanksville, Pa., did not know they were on a suicide mission." Later translations indicated that the terrorists knew they were on a martyrdom mission but were kept ignorant of any details until the last moments.

WHERE'S OSAMA?

12·19·01

The bombing war in Afghanistan was successful, the Taliban was destroyed, al Qaeda was on the run, and Osama bin Laden was nowhere to be found. Meanwhile, Cleveland Browns football fans had gone on a bizarre beer bottle-throwing rampage on December 16 after a game against Jacksonville, in response to official injustice. Could it be . . .?

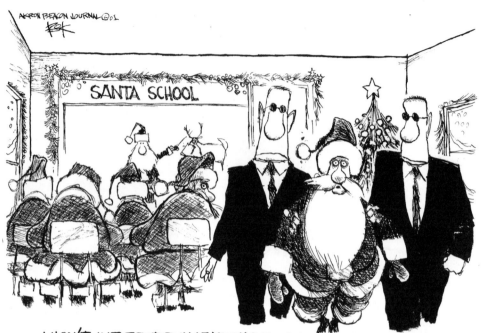

WASN'T INTERESTED IN LEARNING HOW TO LAND THE SLEIGH

12·20·01

As Christmas approached, the government had begun a relentless crackdown on foreign nationals engaged in the slightest suspicious activity. One alleged potential hijacker was tripped up by his lack of interest in learning to land the plane when he was in flight school.

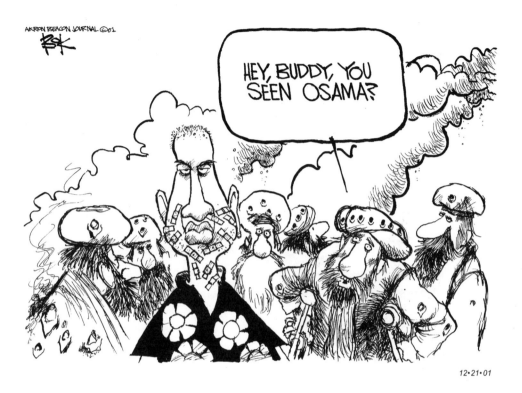

With the Taliban shot up and in disarray, some men shaved their beards to conceal their identity with the defeated government. Would the evil one himself have done the same?

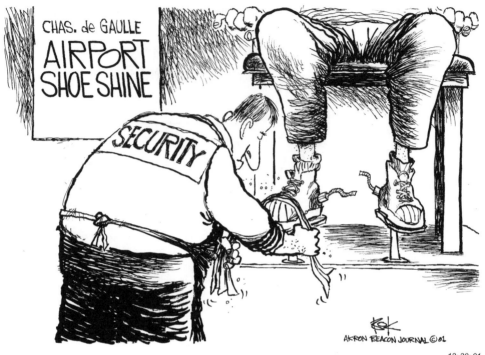

CHAS. de GAULLE
AIRPORT
SHOE SHINE

SECURITY

AKRON BEACON JOURNAL © 01

12·30·01

Passengers and crew members on a holiday flight from Paris to Miami subdued a scruffy, foul-smelling passenger as he tried to light his tennis shoe. He was the now famous tennis shoe bomber, Richard Reid. He fit every terrorist profile, but nobody thought to look for the bomb in his sneaker.

President Bush had proclaimed his intent to treat countries that harbor terrorists in the same way as the terrorists themselves. That way he justified invading Afghanistan and destroying the Taliban in order to get to the al Qaeda terrorists. Complications were bound to arise, and they did when Pakistani terrorists attacked the Indian Parliament. India felt it had a right to invade Pakistan, and why not?

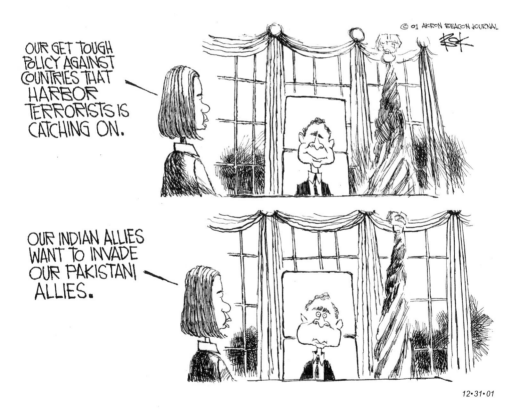

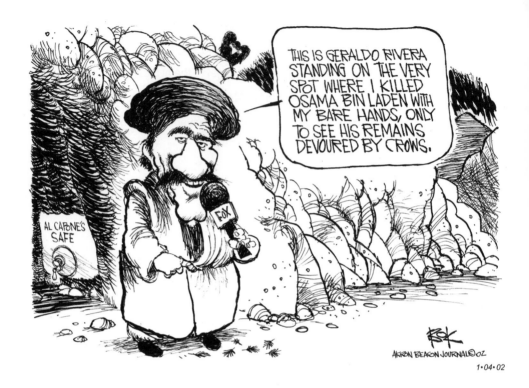

Geraldo Rivera said the Lord's Prayer over "hallowed ground" where he saw three American soldiers killed by friendly fire. *Baltimore Sun* reporter David Folkenflik later revealed that Geraldo was reporting from Tora Bora and the friendly fire incident happened hundreds of miles away near Kandahar. Geraldo blamed his impaired vision on the "fog of war."

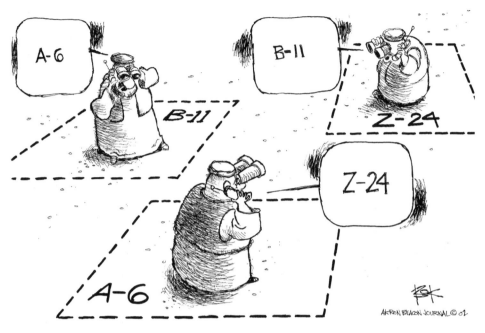

OUR AFGHAN WARLORD ALLIES CALL IN BOMBING CO-ORDINATES ON THE ENEMY

1·06·02

With allies like these, who needs enemies? In order to bomb the Taliban and al Qaeda from the safety of high altitude, the U.S. depended on its Afghan allies on the ground. Unfortunately, our warlord allies had their own agenda, which was primarily to kill each other. This could account for almost accidental friendly fire.

As the American war on terrorism escalated in Afghanistan, Palestinian terrorists picked up the pace in Israel and the occupied territories. Suicide bombings and the Israeli response became increasingly brutal. Claims that American support for Israel brought on the September 11 attacks ignored the lack of radical Muslim interest in the plight of the Palestinians before September 11. Bin Laden supporters probably were not disappointed to see the peace process pureed.

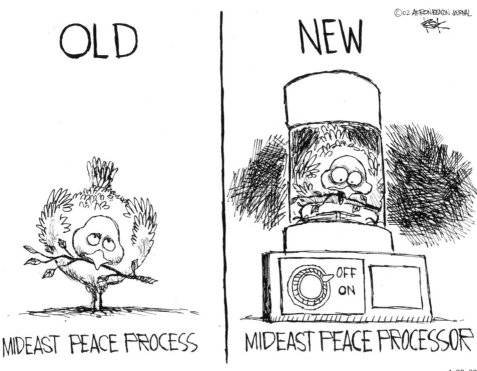

© 02 AKRON BEACON JOURNAL

OLD

NEW

MIDEAST PEACE PROCESS

MIDEAST PEACE PROCESSOR

1·08·02

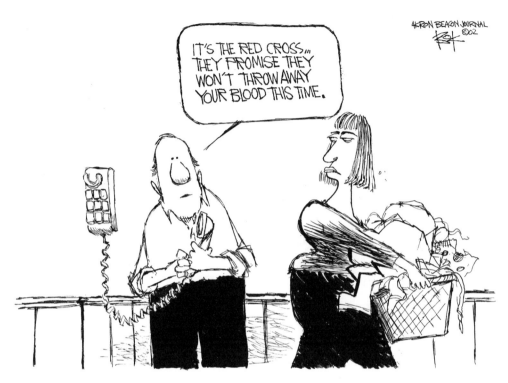

The Red Cross took in more blood than it could use for victims of the World Trade Center disaster and had to throw out some of it. It was not long before they came up short and had to ask for more.

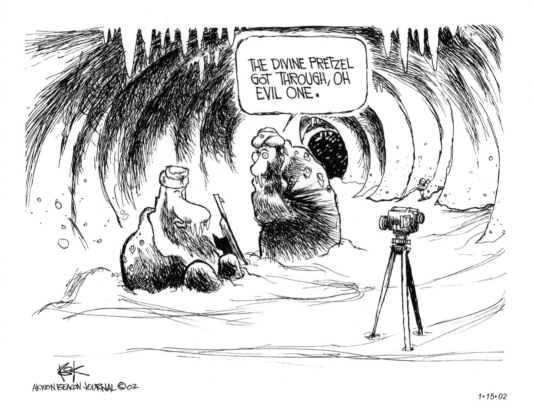

President Bush, while watching a football game, alone in his room except for his two dogs, choked on a pretzel, passed out, fell on the floor, and hit his head.

The three firefighters raising the American flag in the rubble of the World Trade Center were depicted in an ethnically correct manner in a proposed memorial sculpture. That means each of them was portrayed as a member of a different ethnic group, even though all three were apparently of the Caucasian variety. How this was discernible in a bronze statue I'm not exactly sure, but it did cause a fuss. Perhaps other war memorials could also be corrected for race, creed, color, gender, sexual orientation, and pet preference.

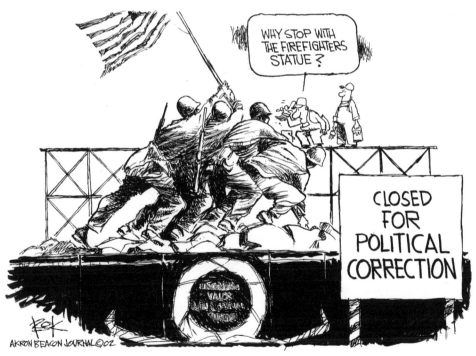

1·16·02

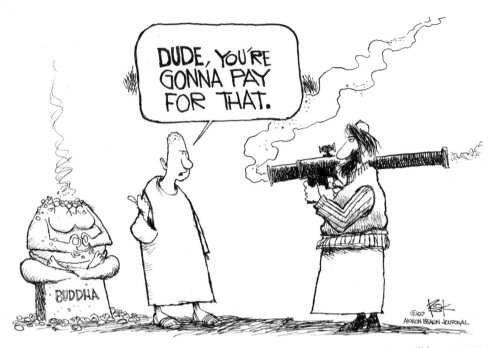

EARLY SIGN THAT JOHN WALKER WAS DIFFERENT FROM THE OTHER KIDS IN MARIN COUNTY, CALIFORNIA

1·17·02

John Walker Lindh, the young American captured with the Taliban in Afghanistan, grew up in Marin County, California, and became a convert to Islam there. That struck me as ironic because that part of California, especially in the Midwestern mind, is Lotus land. The place is crawling with Buddhists, and if there is anything a good Taliban hates, it's graven images. In fact, the Taliban blew up two ancient Buddha statues guarding the Bamiyan Valley on March 8 and 9, 2001, just to prove their point. I imagine that sort of behavior would be considered inappropriate in Marin County.

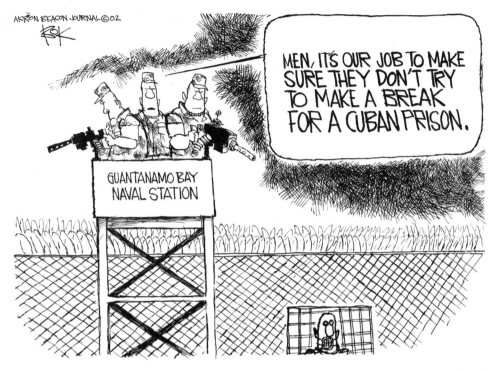

AKRON BEACON JOURNAL ©02

MEN, IT'S OUR JOB TO MAKE SURE THEY DON'T TRY TO MAKE A BREAK FOR A CUBAN PRISON.

GUANTANAMO BAY NAVAL STATION

1·20·02

A photo showing al Qaeda prisoners at the Guantanamo Bay Naval Station, Cuba, in leg irons and with covers over their eyes and ears set off a storm of protest in Europe. The United States was accused of ignoring the Geneva Convention. The argument was even more interesting than the pictures. The United States claimed that the men were captured in the war on terrorism but are not prisoners of war. The critics claim the war on terrorism is not a war but that the prisoners should be considered prisoners of war. Wonder what the neighbors thought?

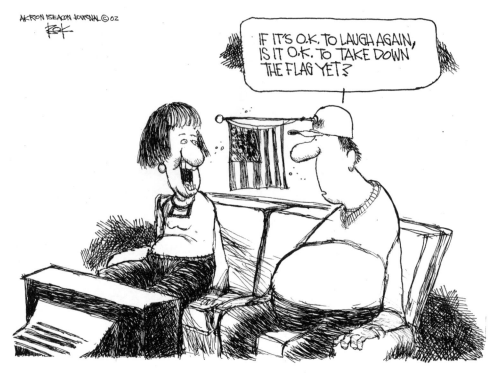

At some point the time arrives for patriots to take down the flags from their windows, car antennae, and wherever else they proudly wave in the simulated breeze. The challenge is how to do that without being mistaken for a terrorist sympathizer.

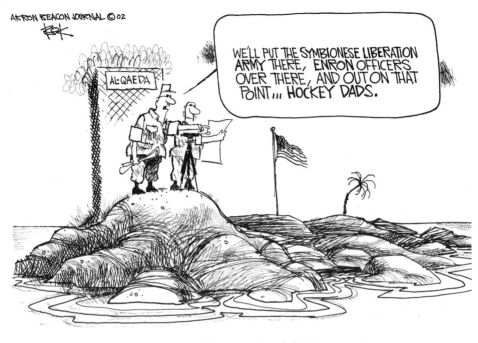

GITMO BUILDS OUT

1·27·02

It seemed al Qaeda fighters were not the only ones bucking for a spot on Gitmo. Members of Patty Hearst's old gang as well as deadly hockey dads were being sentenced to prison.

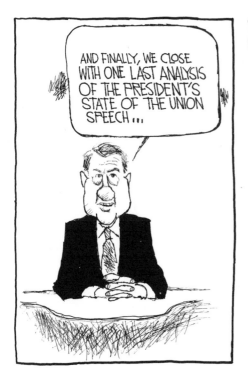
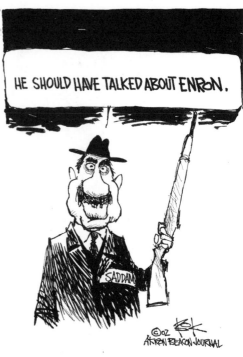

1·31·02

Many hoped that President Bush would address concerns about the collapse of the Enron energy trading company in his State of the Union speech. Instead he talked about the axis of evil: Iran, North Korea, and Iraq.

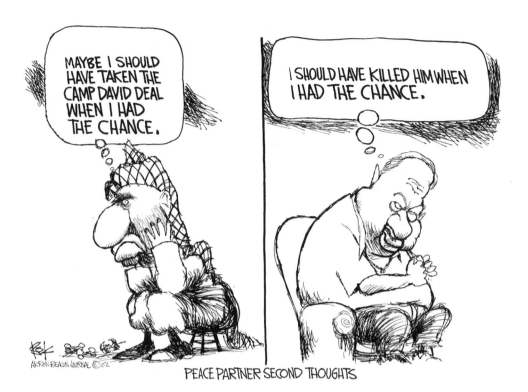

PEACE PARTNER SECOND THOUGHTS

2·04·02

A pair made for each other: Ariel Sharon and Yasser Arafat. Arafat, having refused to take yes for an answer at the Camp David peace talks, now found himself surrounded by Israeli tanks and confined to his compound. The suicide bombings increased and Sharon, in frustration, retaliated more violently to each provocation. He actually said he wished he had killed Arafat when he had him cornered in Lebanon twenty years before.

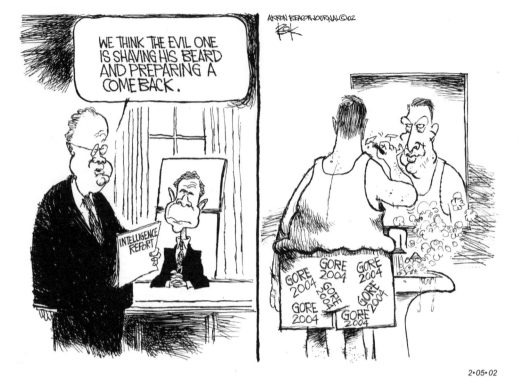

President Bush's bearded arch-nemesis was back in

the picture.

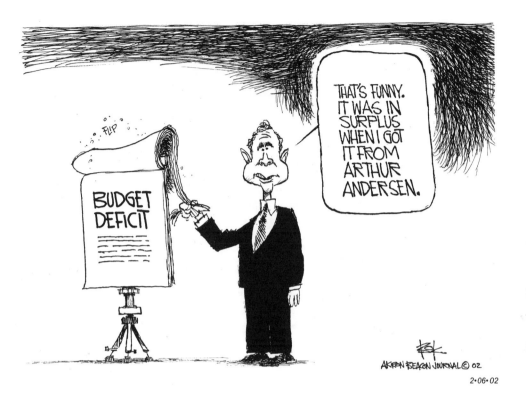

The war on terrorism and the recession gobbled up the federal surplus. The president was trying mightily to distance himself from his close ties to Ken Lay and the Enron collapse. He could have used some help from Enron's flexible accounting firm, Arthur Andersen.

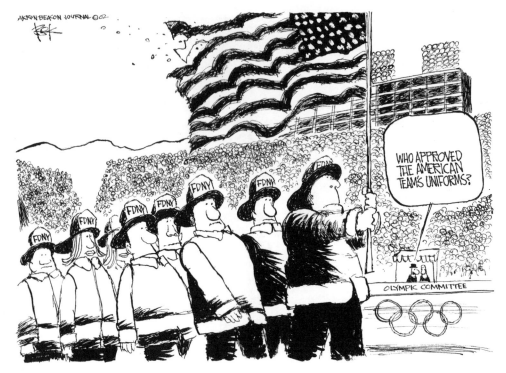

The International Olympic Committee balked at allowing the torn flag from the World Trade Center to be flown at the winter games. As it turned out, the flag was too frail to withstand the stress anyway. A compromise was reached to permit the flag to be carried in during the opening ceremonies.

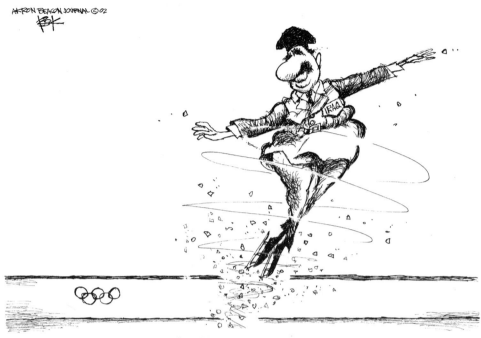

AXLE OF EVIL

2·12·02

Well, I found it amusing.

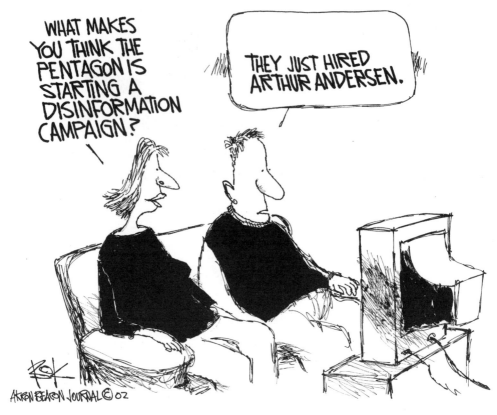

The Pentagon created a new Office of Strategic Influence
for spreading lies. When the truth got out about it, they shut
it down.

Wall Street Journal reporter Daniel Pearl was kidnapped and murdered on videotape by Islamic terrorists in Pakistan. The act was so grisly and so pointless I began to wonder if what they really wanted was simply blood.

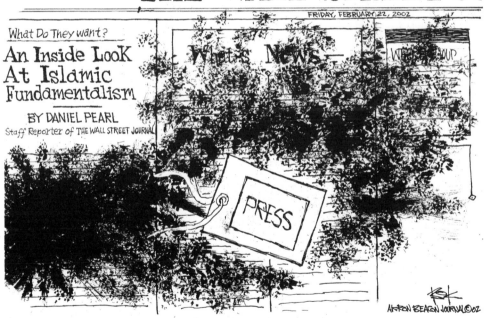

THE WALL STREET J(

FRIDAY, FEBRUARY 22, 2002

What Do They want?

An Inside Look At Islamic Fundamentalism

BY DANIEL PEARL
Staff Reporter of THE WALL STREET JOURNAL

What's News

PRESS

AKRON BEACON JOURNAL ©02

2·24·02

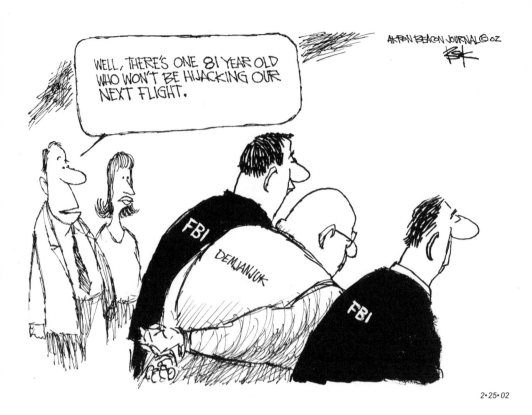

Eighty-one-year-old John Demjanjuk, of Cleveland, long suspected
of being the Nazi concentration camp guard Ivan the Terrible during
World War II, was once again stripped of his citizenship.

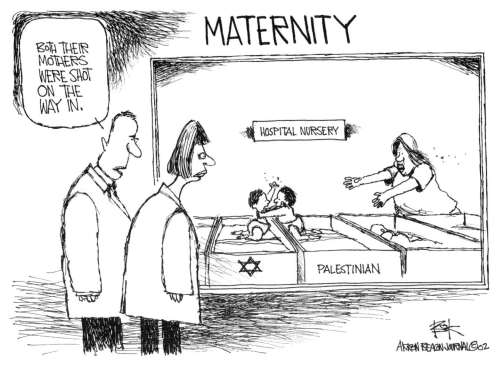

Civilized behavior didn't seem imminent in the Middle East. On the same day, in separate locations, a pregnant Israeli woman and a pregnant Palestinian woman were shot on the way to hospitals to deliver their babies. Both women and babies survived.

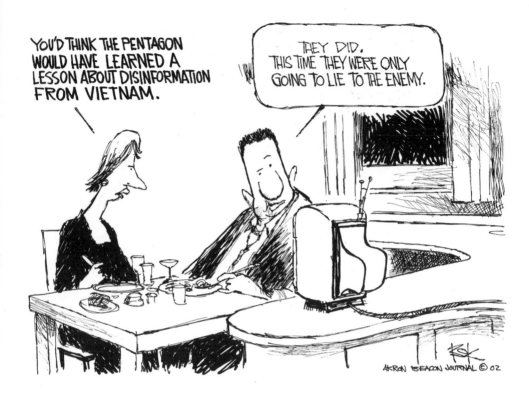

If the Pentagon kills the enemy, is it unethical to lie to

the enemy?

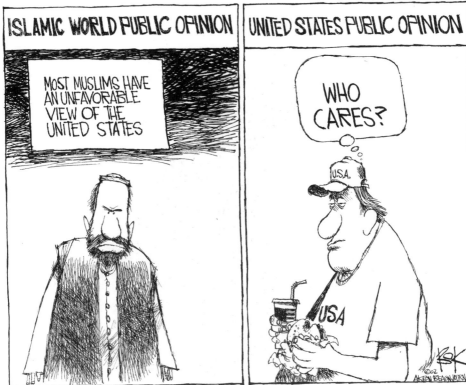

A Gallup Poll of Muslims found that the majority had an unfavorable view of the United States. Sixty-six percent did not believe Arabs were involved in the September 11 attacks. No one at that time conducted a poll about American attitudes toward the Islamic attitudes.

AKRON BEACON JOURNAL © 02

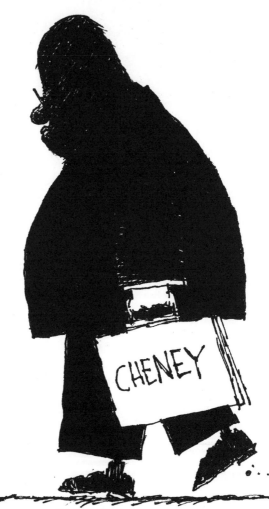

CHENEY

SHADOW GOVERNMENT

In the immediate aftermath of the terror attacks on the United States, the Bush administration began operating a shadow government, or more accurately, a shadow executive branch, considering Congress was not even informed. I wondered if a shadow government would be any less corrupt than a well-lighted government.

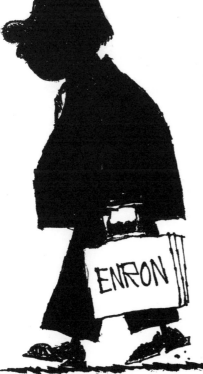

SHADOW CONTRIBUTOR

3·03·02

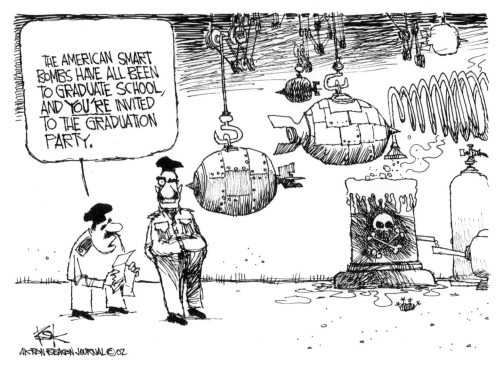

American smart bombs had grown much smarter since Desert Storm.

Kosovo and Afghanistan had been their graduate schools.

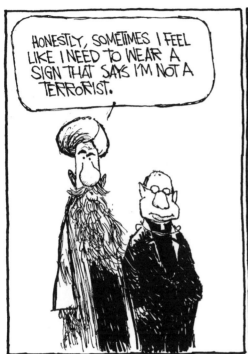
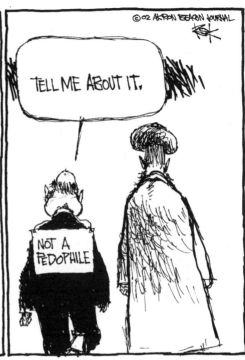

Not all Muslims are terrorists. Not all priests are perverts. Not all cartoonists are unsympathetic.

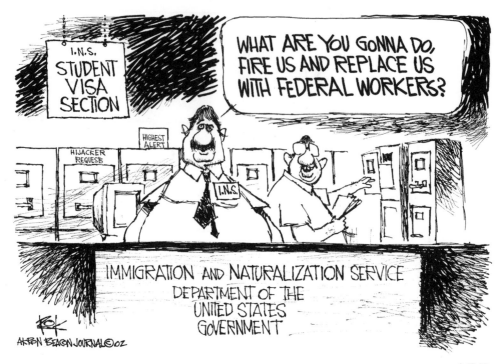

The Immigration and Naturalization Service issued new student visas to two dead hijackers. The notification was received at Huffman Aviation International flight school in Venice, Florida, the training site of Mohamed Atta and Marwan Al-Shehhi, on March 11, 2002. It makes you wonder what the government hoped to accomplish by replacing private security workers at airports with more costly (and allegedly more competent) government workers.

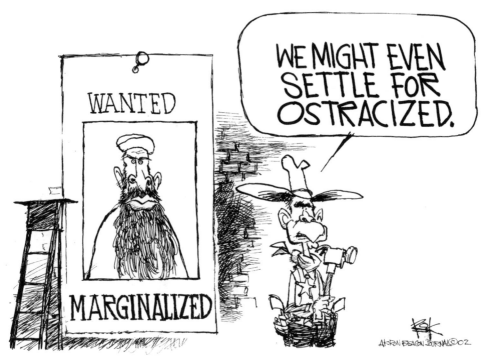

President Bush said it's not important that Osama bin Laden got away.
He could be dead or he could be in hiding, but the important thing is that
he has been marginalized.

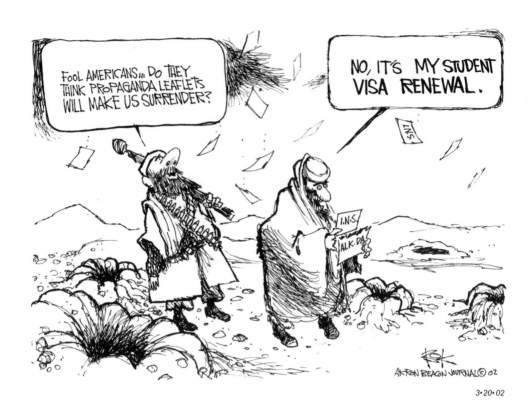

During Operation Anaconda, U.S. troops on the ground trapped al Qaeda holdouts in the mountains of Eastern Afghanistan, while allied aircraft tried to pound them into submission.

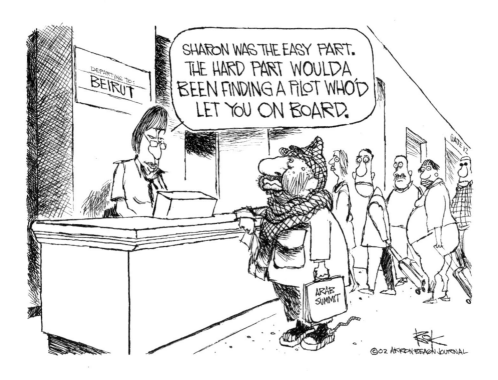

Osama bin Laden tried to associate al Qaeda's madness with the justifiable anger of the Palestinians. Palestinian militants returned the favor by suicide bombing innocent people. Ariel Sharon responded by attacking Yasser Arafat's compound and holding him there. This frustrated Arafat's desires to travel from his digs in the West bank to the Arab summit in Beirut.

President Bush's doctrine of punishing terrorists and those who harbor them may have applied to the PLO. In many respects, however, the Israeli-Palestinian conflict seemed long ago to have devolved into a personal feud between two old men.

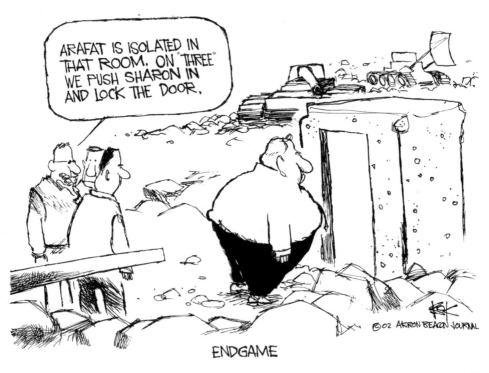

ENDGAME

4·02·02

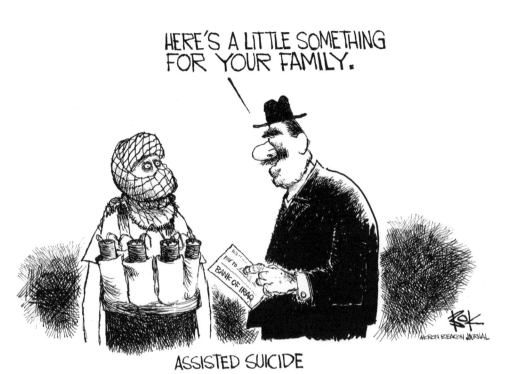

The concept of martyrdom through suicide bombing is a difficult one for the Western mind. Assisted suicide, however, is a popular concept in Europe and America for the terminally ill. One argument against it is that the old, the sick, and the weak might feel pressure to have themselves done in if it would relieve their loved ones of a financial burden. A financial incentive to help grease the skids is something we can all understand.

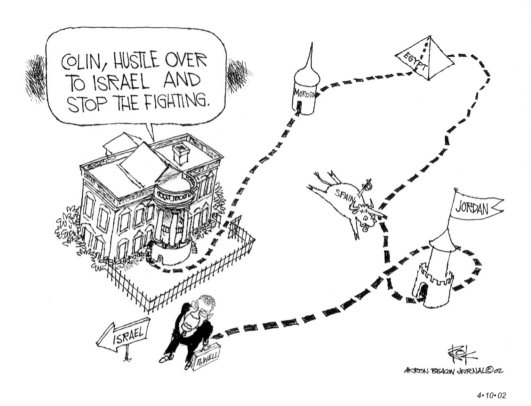

Bush decided enough was enough, and sent Secretary of
State Colin Powell to the Middle East to stop the fighting,
eventually.

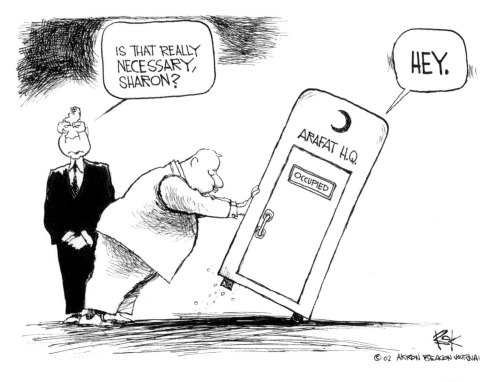

With Yasser Arafat confined to a room with no way out,
Ariel Sharon seemed to take a peculiar delight in his ad-
versary's predicament.

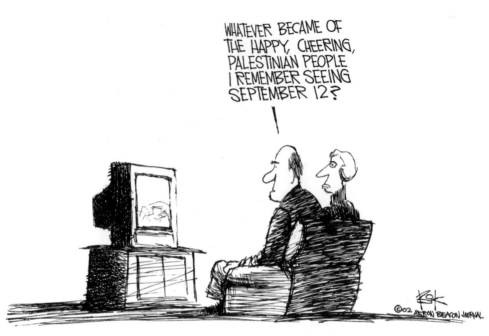

Under the thumb of Ariel Sharon, the Palestinian people didn't have much to cheer about. They were oppressed, their homes were destroyed, and they were treated brutally. On the other hand, the last time we saw Palestinians with something to cheer about was the day after the World Trade Center bombings.

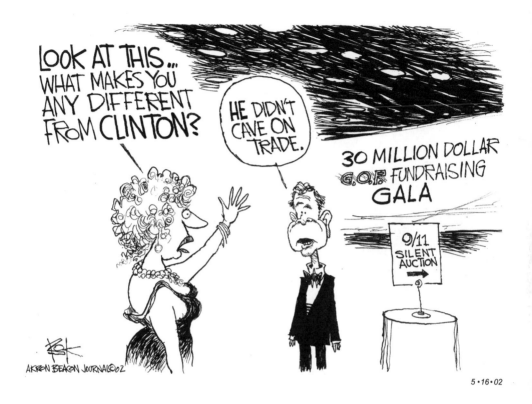

Republicans offered a photo of President Bush speaking on the phone with Dick Cheney about the September 11 attacks as a political fundraiser. They were promptly accused of trying to capitalize on the tragedy. The remark about Clinton not caving on trade refers to Bush giving in to protectionist influences, especially for steel, and not obtaining fast track authority on international trade negotiations.

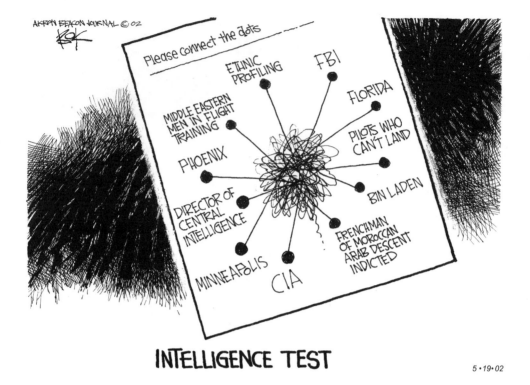

INTELLIGENCE TEST

5·19·02

Phoenix FBI agent Ken Williams wrote a memo on July 10, 2001 expressing his suspicions about Middle Eastern men in U.S. flight schools. In August 2001 an FBI agent in Minnesota wrote that Zacarias Moussaoui might be contemplating the flying of a jet into the World Trade Center. The FBI refused to seek search warrants for Moussaoui. The failure of intelligence agencies to connect the dots led to criticism of the Bush administration for not anticipating the September 11 attacks.

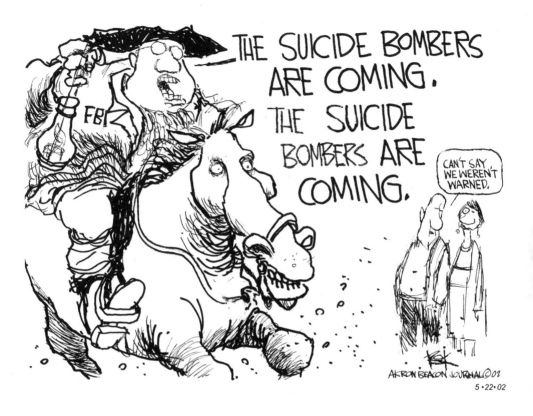

Around the Memorial Day holiday of 2002 we began to receive all manner of warnings of possible terrorist attacks on just about anything and everything. Vice President Cheney warned there would be another attack, it was just a matter of when and where. Could this have been a response to the criticism that the authorities didn't do enough to prevent the September 11 attacks?

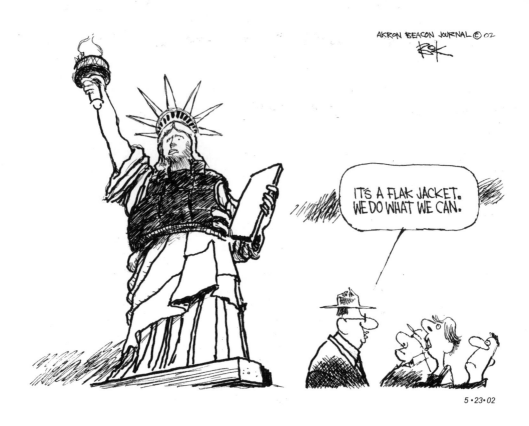

The Statue of Liberty and the Brooklyn Bridge were among specific possible targets mentioned in the new terror attack warnings. We had more warnings, but it still wasn't clear what people were supposed to do about it.

The war on terrorism continues, as the president said it would, very possibly even for a second term, but this is where I am going to leave it. For now. It began as an unforgivable atrocity, marked by anguish and suffering, along with heroism, courage, and self-sacrifice. It united the nation with resolve and revealed a mayor and a president as we had not seen them before. We found we still have friends in the world, especially the British, and we saw cultural and religious differences in stark relief. We saw an overwhelming display of American military and economic power, as well as world resentment of it. During the past year we've seen the fall of business tycoons and priests and the rise of firefighters and police.

The atmosphere of shock and fear has passed. The period of not making fun of our leader was, thankfully, short lived. Normal human beings can't stay on heightened alert forever, it's too hard to remember Homeland Security Director Tom Ridge's color codes. Maybe we pay more attention and wait a little longer in airports, but in the end, life seems to go on pretty much unchanged for most of us. I hope it stays that way.

THE
RE IS NO
END

©02 ROK

About the Author

Chip Bok has been the staff editorial cartoonist of the *Akron Beacon Journal* since 1987. Through Creators Syndicate, his cartoons appear in over 100 publications, including the *Chicago Tribune, Washington Post, New York Times, Los Angeles Times, Time,* and *Newsweek.* He also serves on the steering committee of The Reporters Committee for Freedom of the Press in Arlington, Virginia. He is a 1974 graduate of the University of Dayton with a BA in English and a minor in sociology.

About the Book

Bok: The 9.11 Crisis in Political Cartoons was designed and typeset by Kachergis Book Design of Pittsboro, North Carolina. The typeface used is Arial, which was designed by the Monotype design staff in 1982.

Bok: The 9.11 Crisis in Political Cartoons was printed on 120gsm Hansol Woodfree and bound by Pacifica Communications of Korea.